THE SATURDAY EVENING POST
AMERICANA
COLORING BOOK

RENDERED FOR COLORING BY
MARTY NOBLE

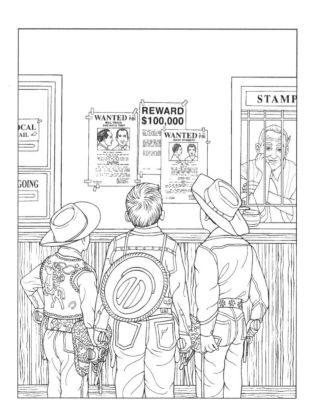

DOVER PUBLICATIONS, INC.
MINEOLA, NEW YORK

It's hard to think of an American publication more iconic than *The Saturday Evening Post,* which has been in print for nearly two hundred years (and possibly has kinship with Benjamin Franklin's *Pennsylvania Gazette,* published in the 1700s). The *Post,* whose first issue appeared on August 4, 1821, has always reflected America's lifestyle, values, and interests. Its content includes feature articles and editorials, short fiction (including stories and poetry by renowned authors such as Edgar Allan Poe, Sinclair Lewis, Dorothy Parker, F. Scott Fitzgerald, and Kurt Vonnegut, Jr.), and cartoons. To many, however, the magazine is forever associated with its covers, many hundreds of which have delighted and moved readers throughout the decades. This unique and delightful coloring book offers an array of coloring opportunities, as you enjoy the illustrations created by some of the *Saturday Evening Post's* most revered cover artists, among them Stevan Dohanos, John Clymer, George Hughes, and John Falter. Printed on the back of each coloring plate are the cover's title, the name of the artist who created it, and its date of publication. The thirty-one plates have been perforated for removal to make displaying your work easy. Enjoy your adventure into this delicious slice of Americana!

Copyright

Illustrations © SEPS. Licensed by Curtis Licensing, Indianapolis, IN.
All rights reserved.

Bibliographical Note

The Saturday Evening Post Americana Coloring Book is a new work,
first published by Dover Publications, Inc., in 2017.

International Standard Book Number

ISBN-13: 978-0-486-81434-6
ISBN-10: 0-486-81434-3

Manufactured in the United States by LSC Communications
81434307 2020
www.doverpublications.com

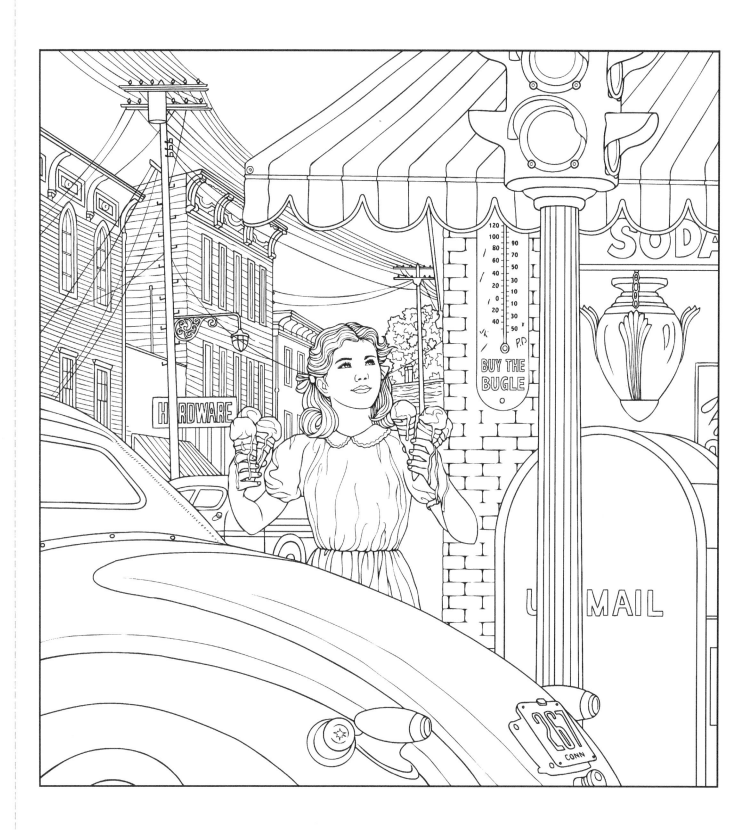

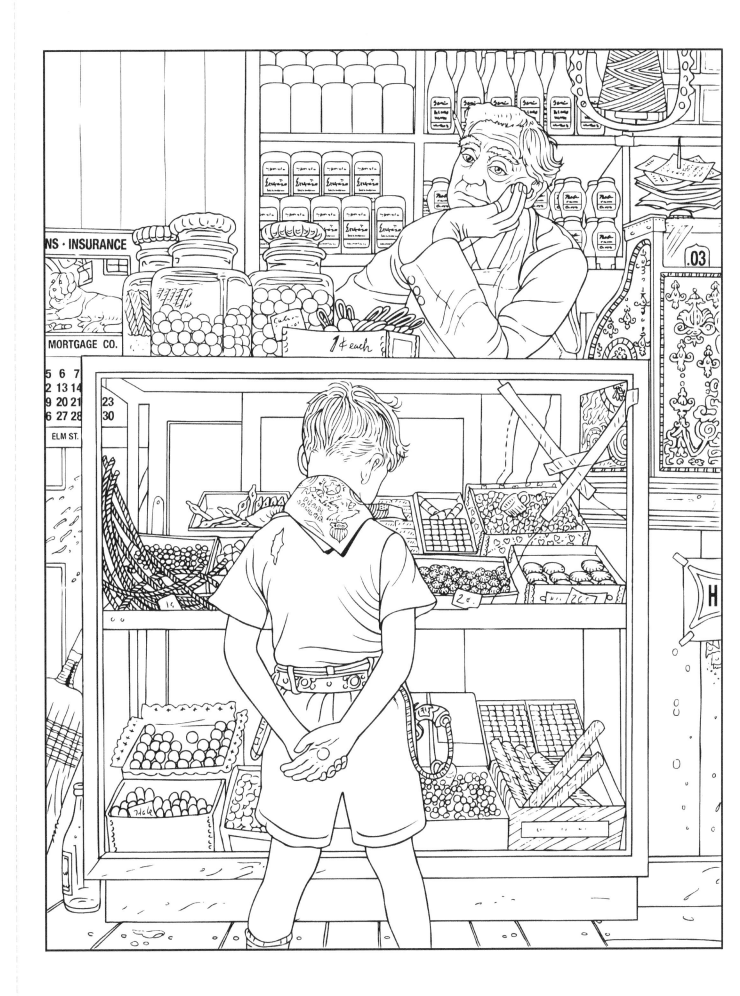

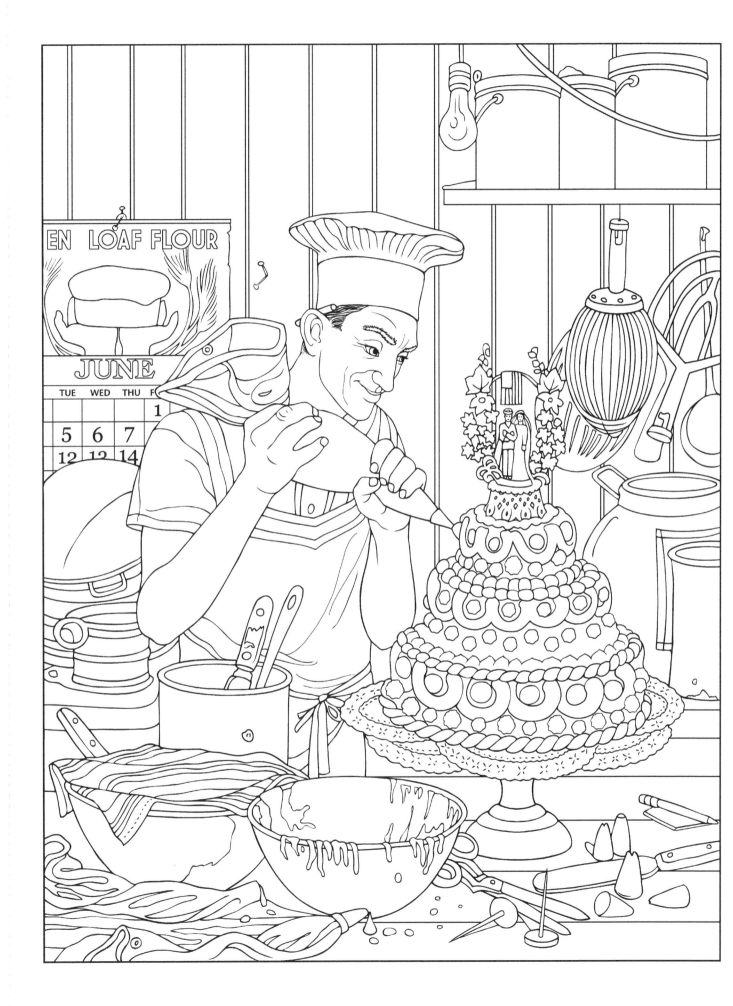

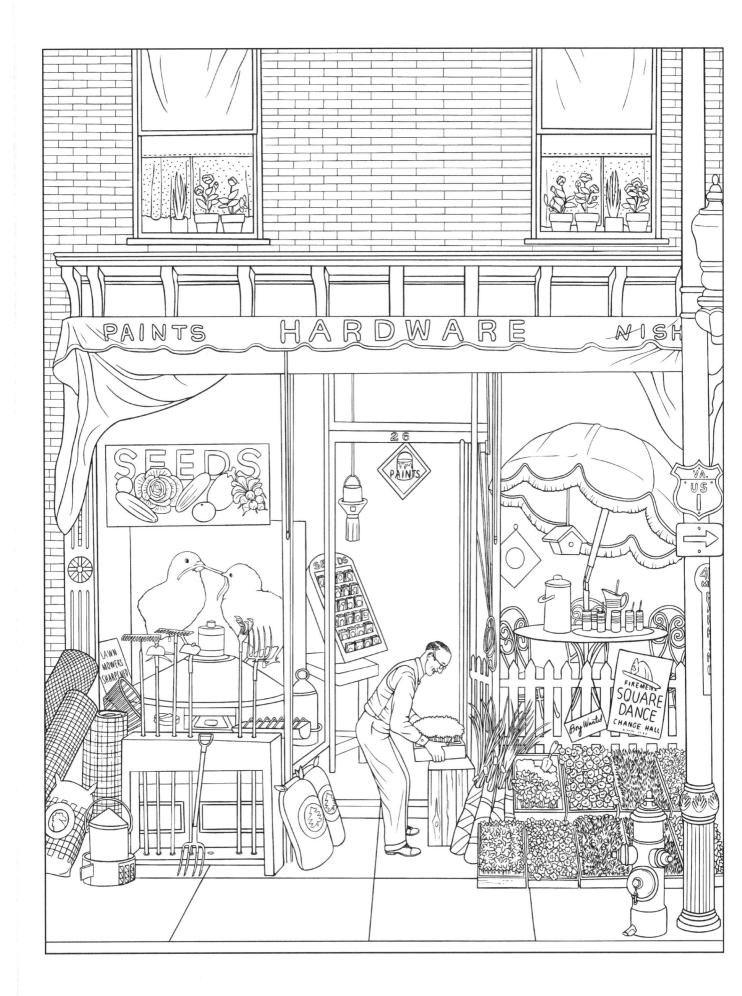

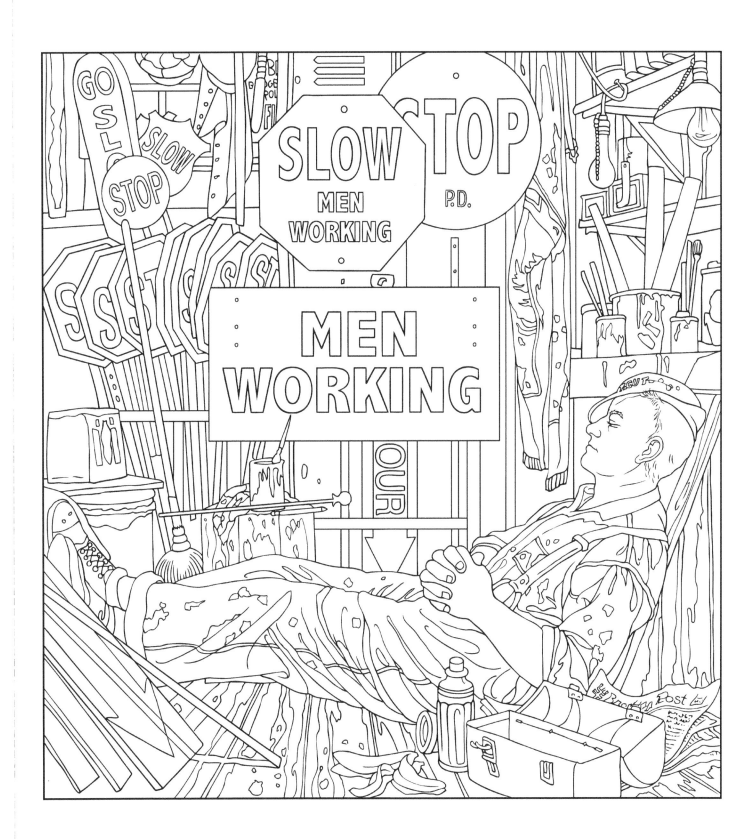

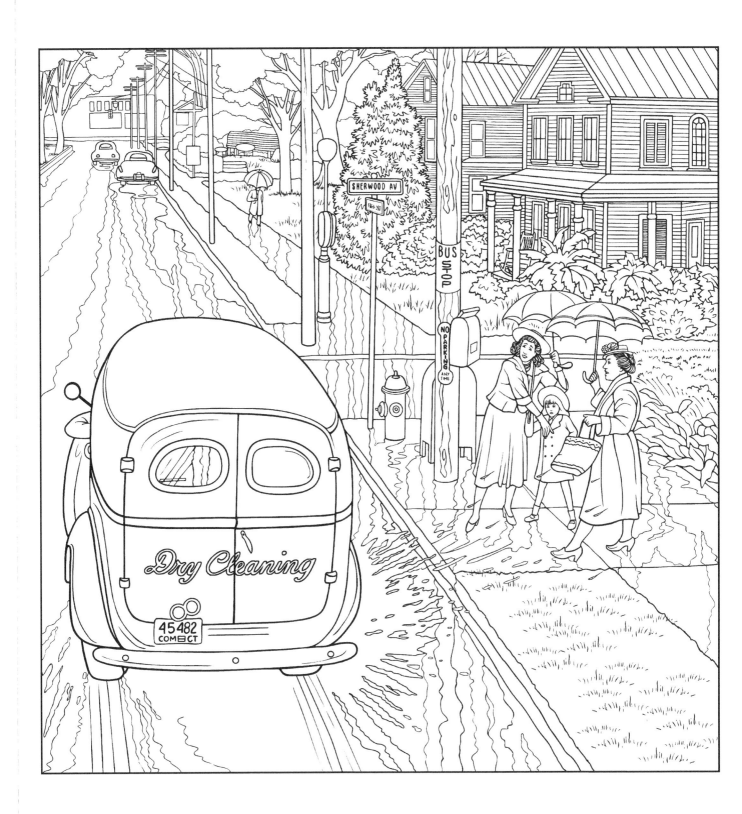

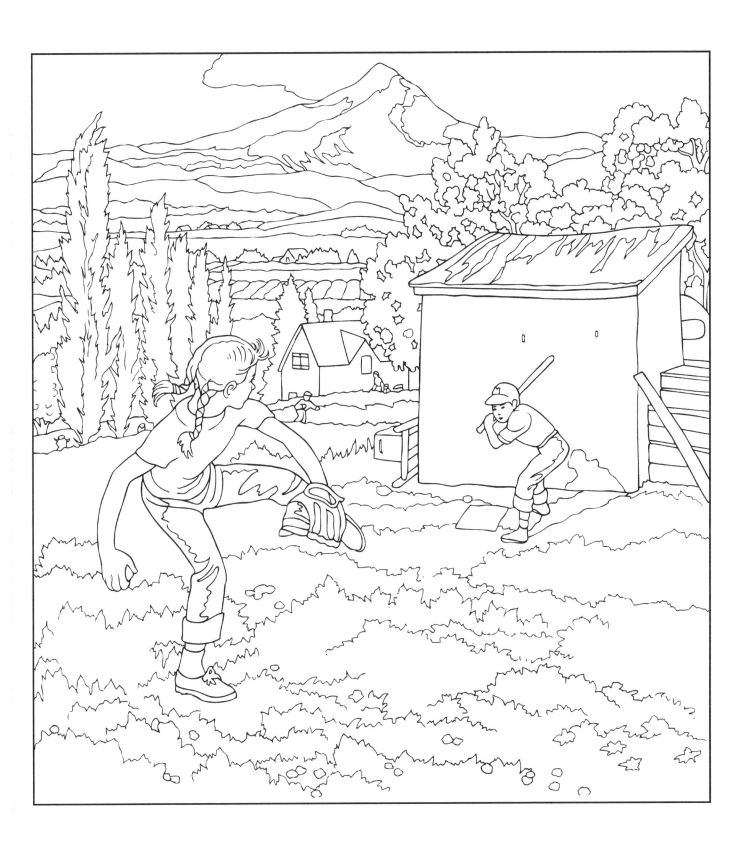

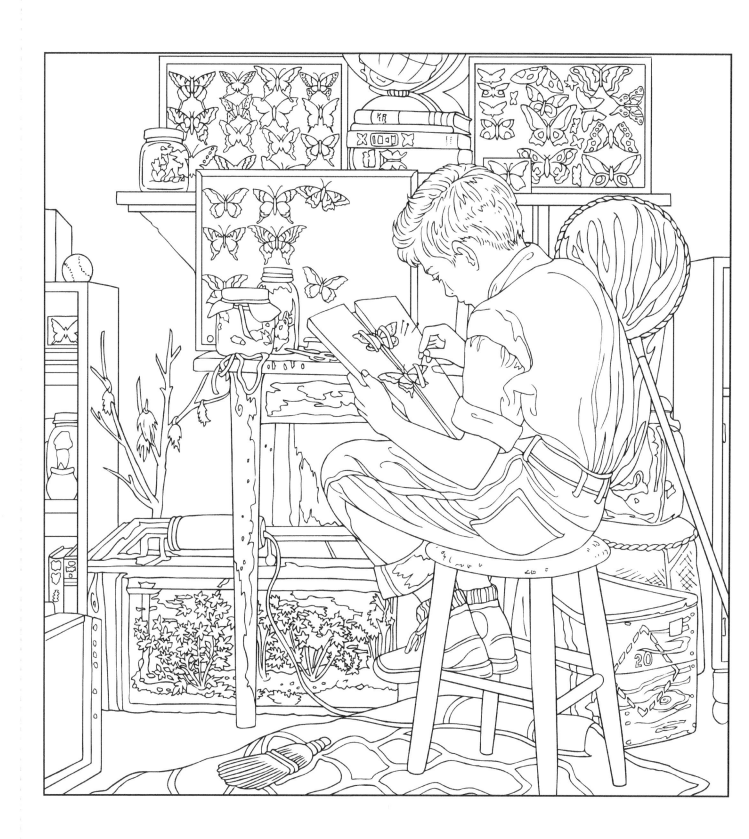

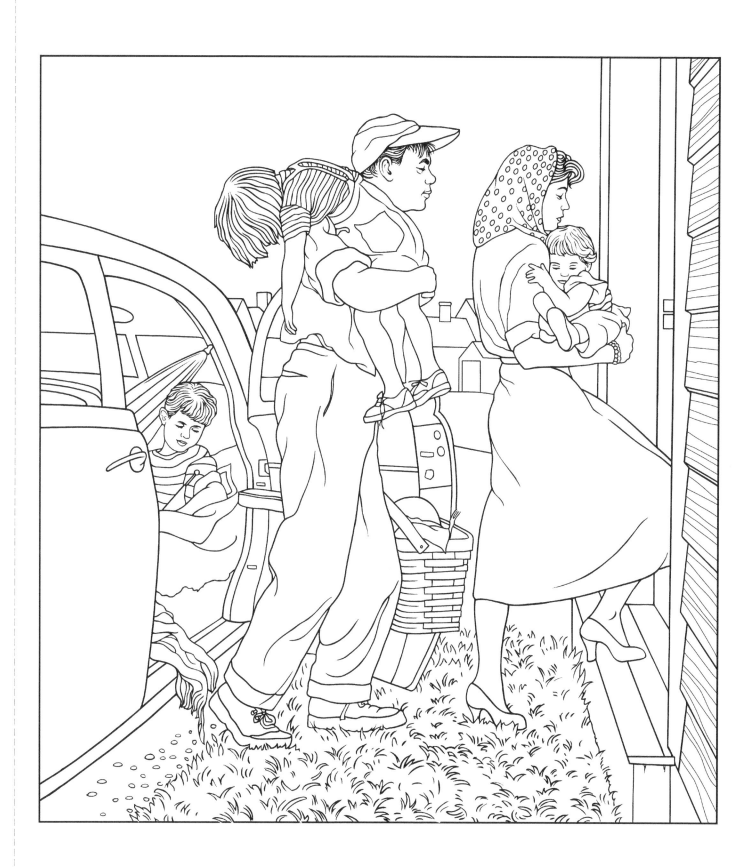

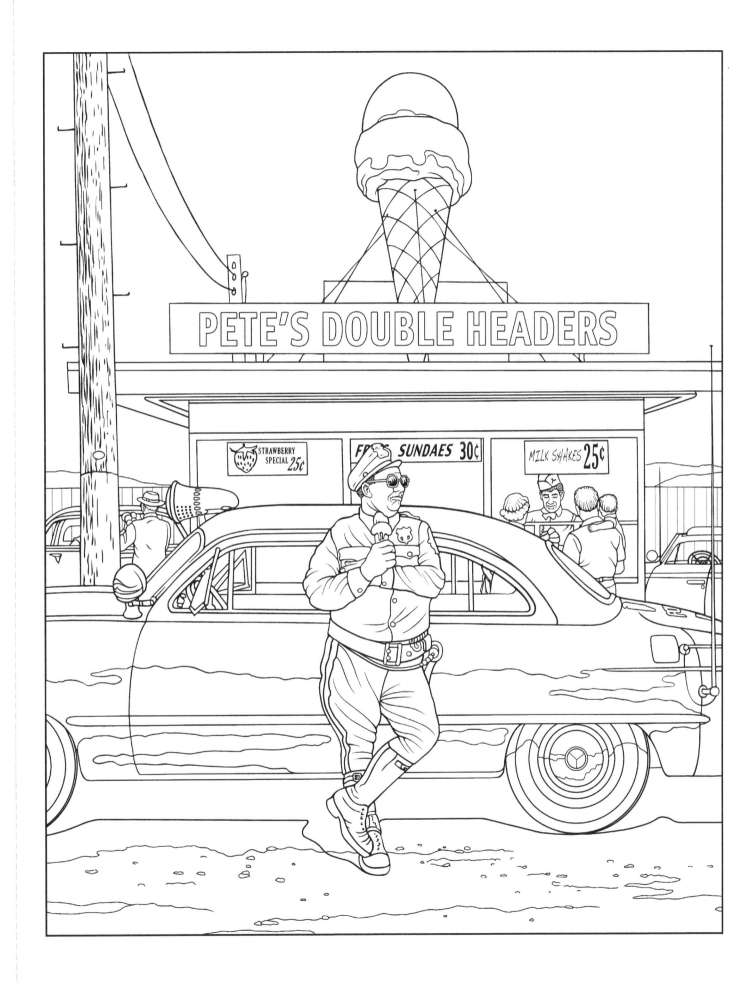

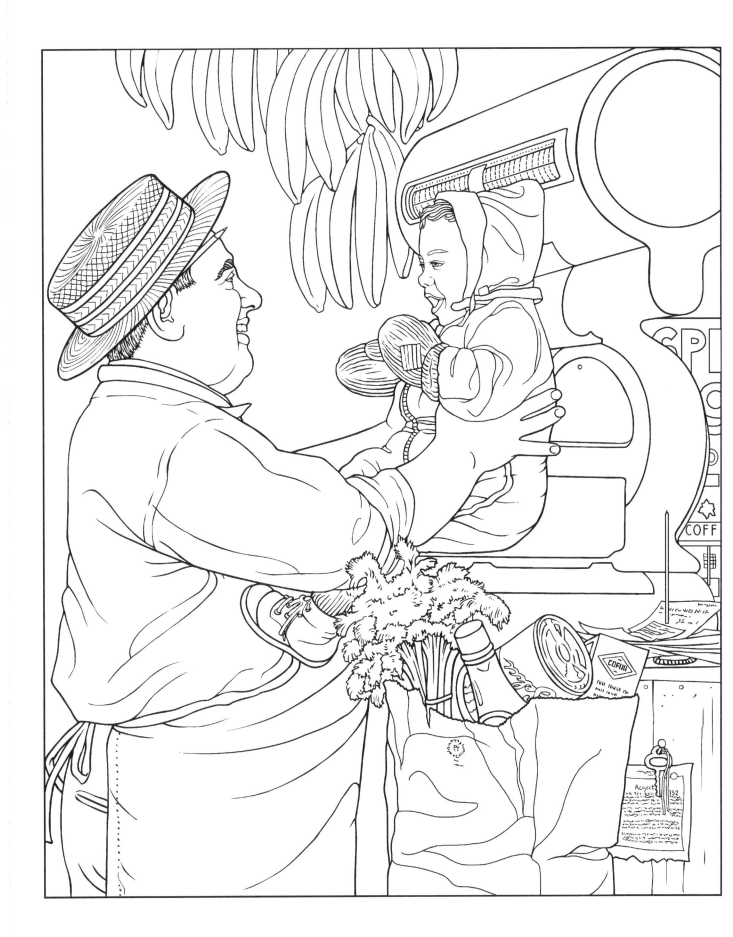

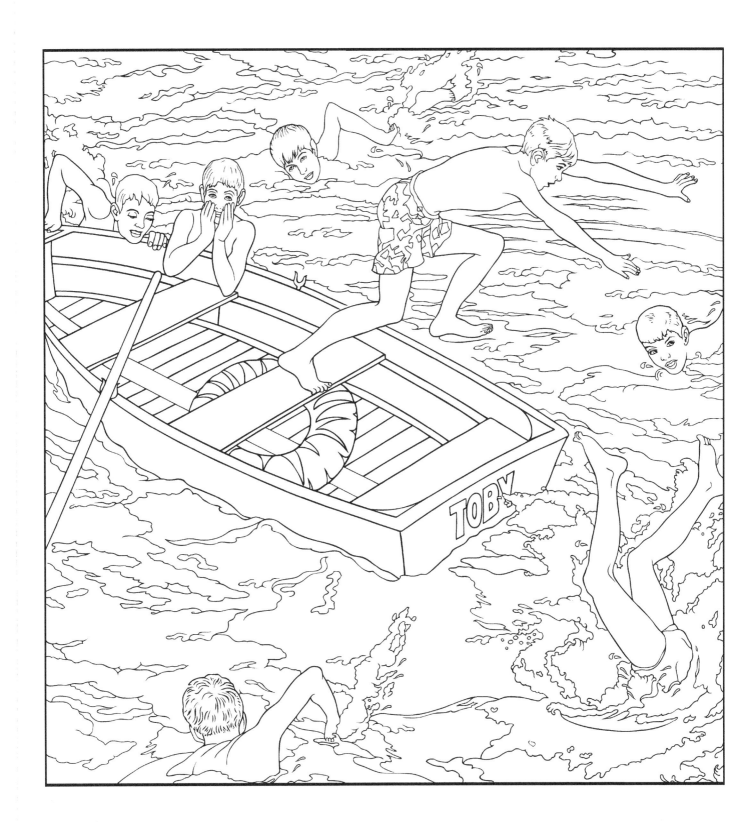

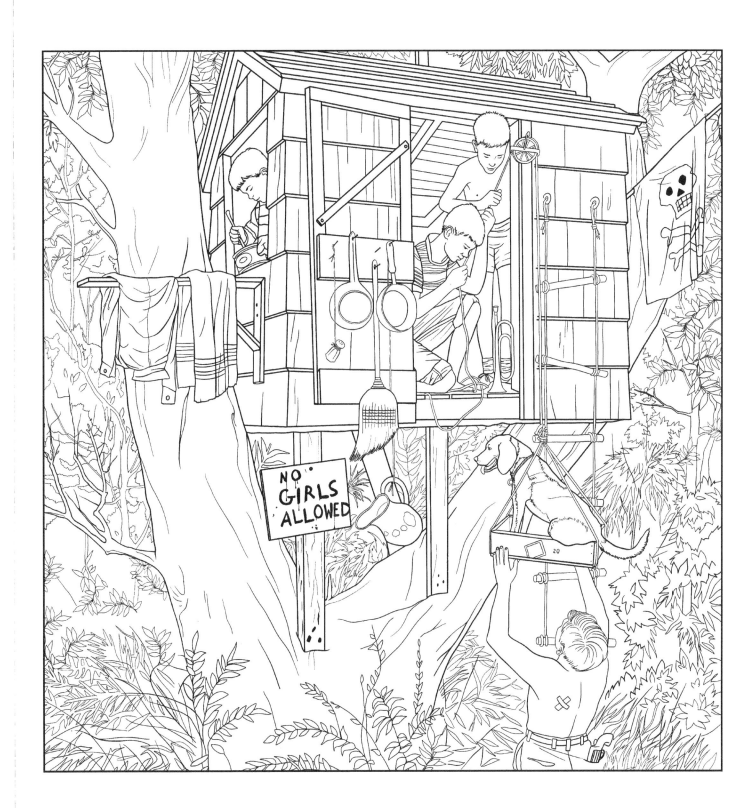

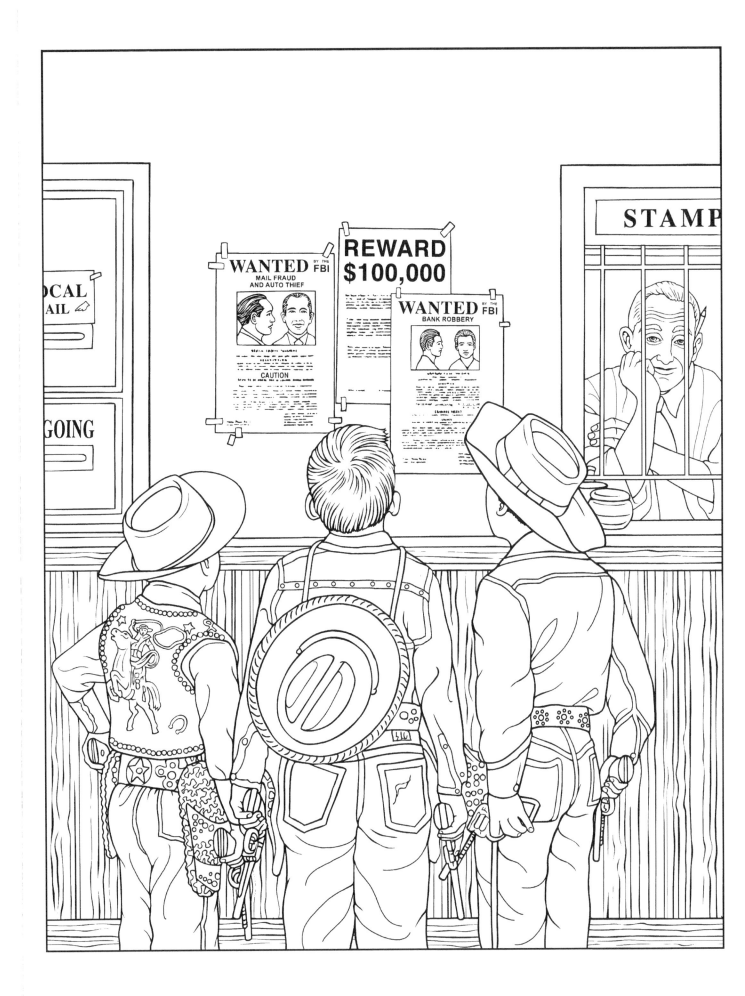

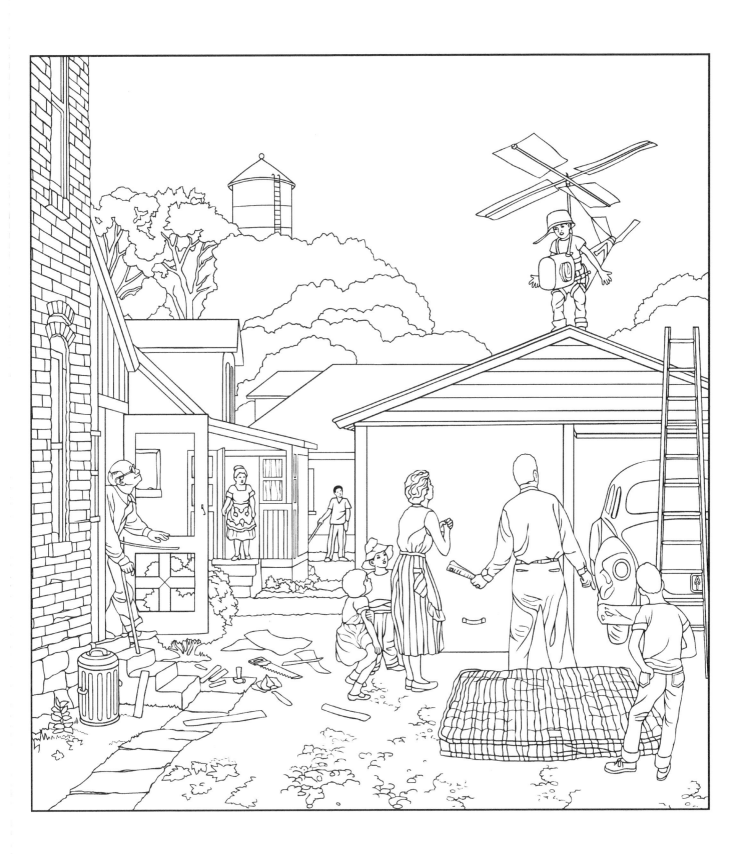

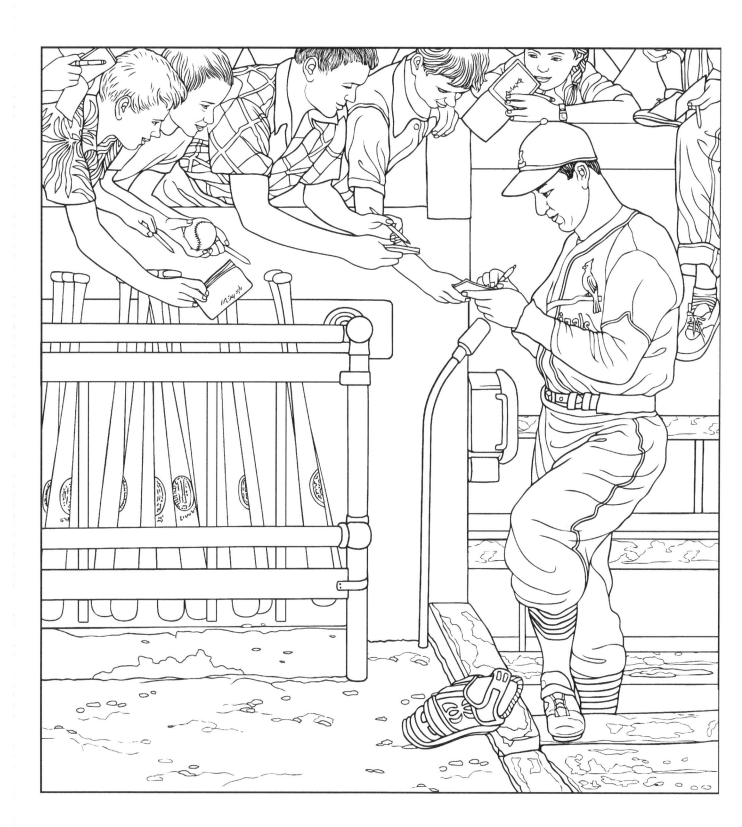

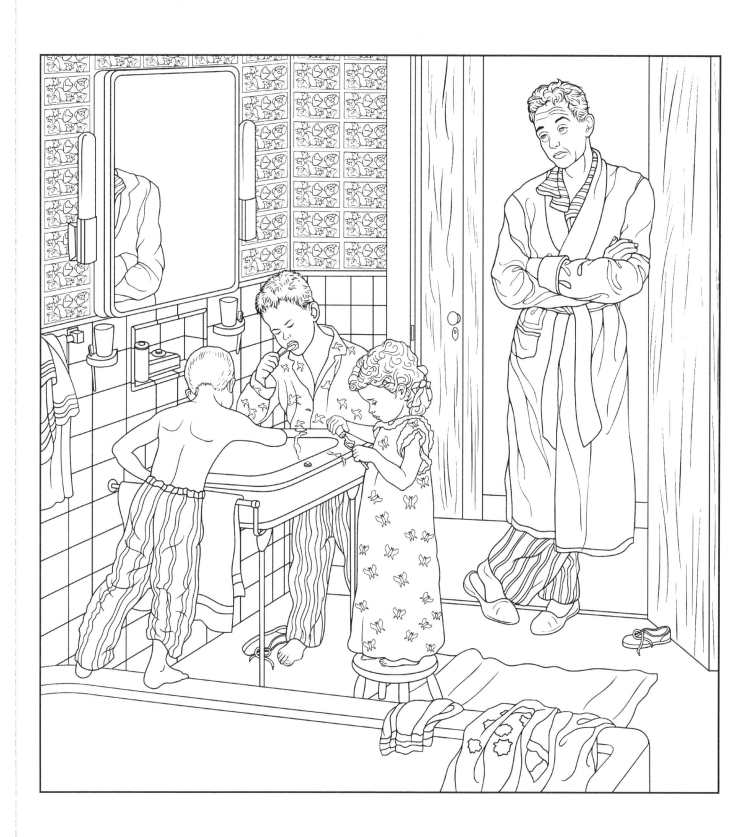

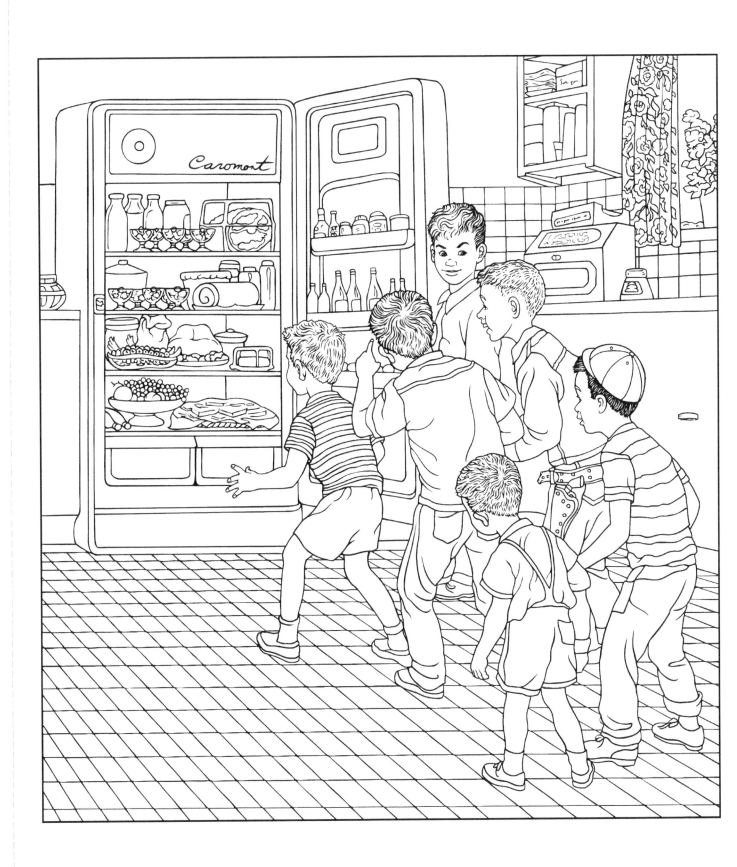

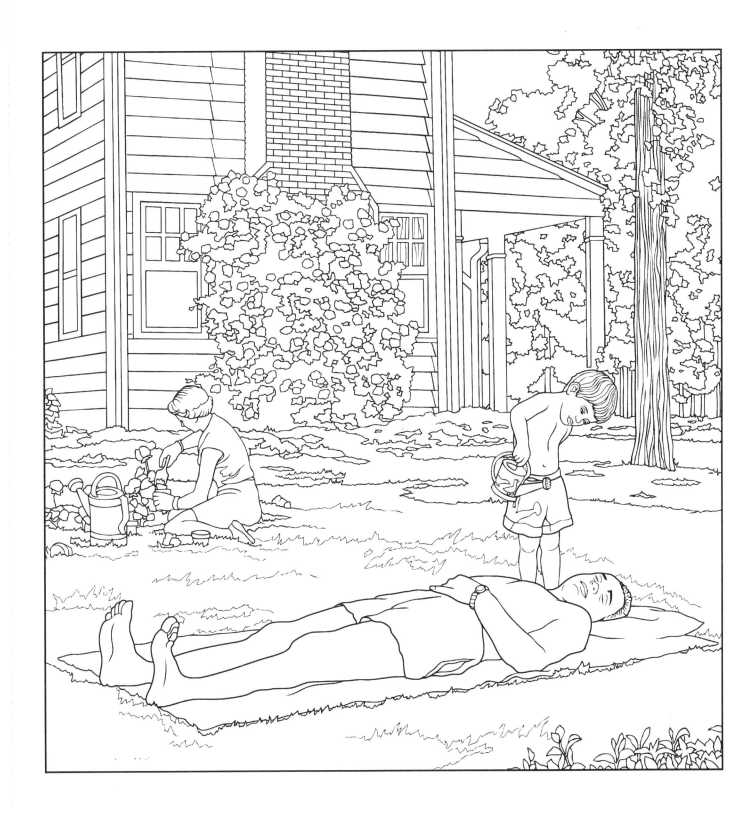

PLATE 19
Watering Father
Richard Sargent
Saturday Evening Post Cover, June 4, 1955

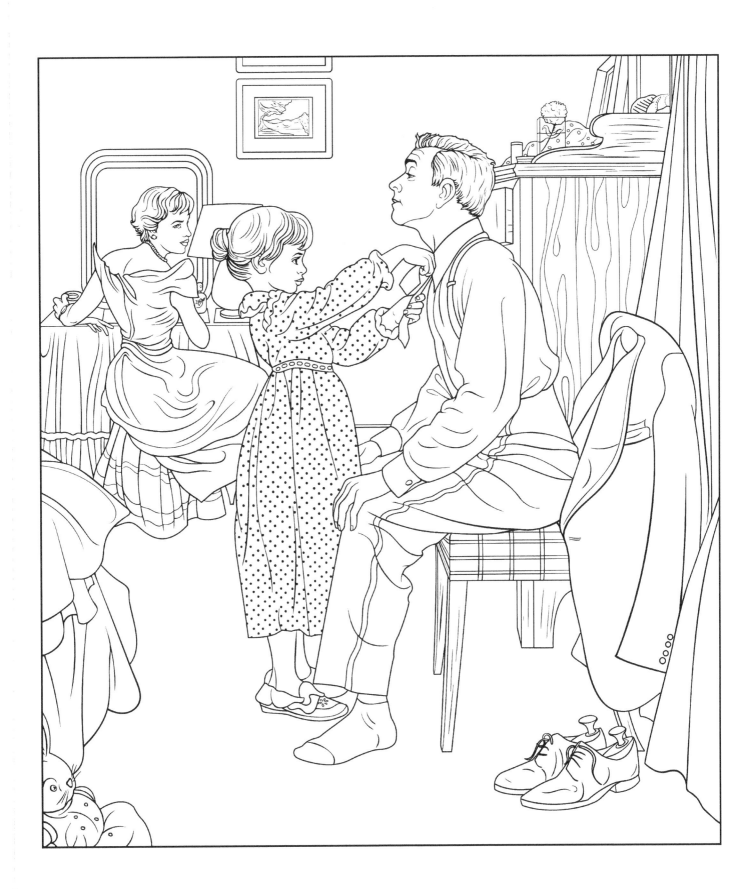

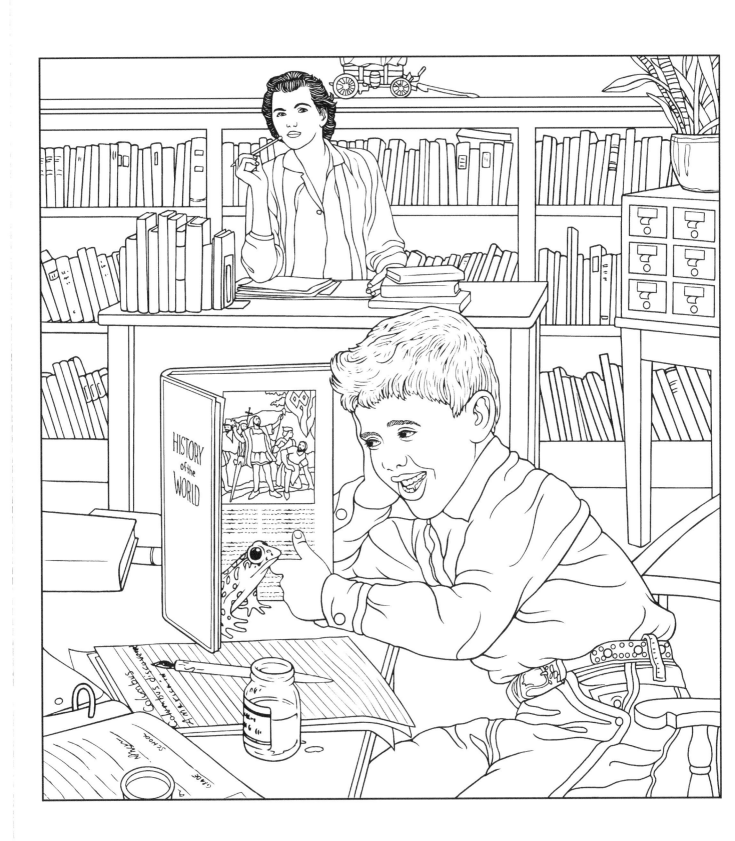

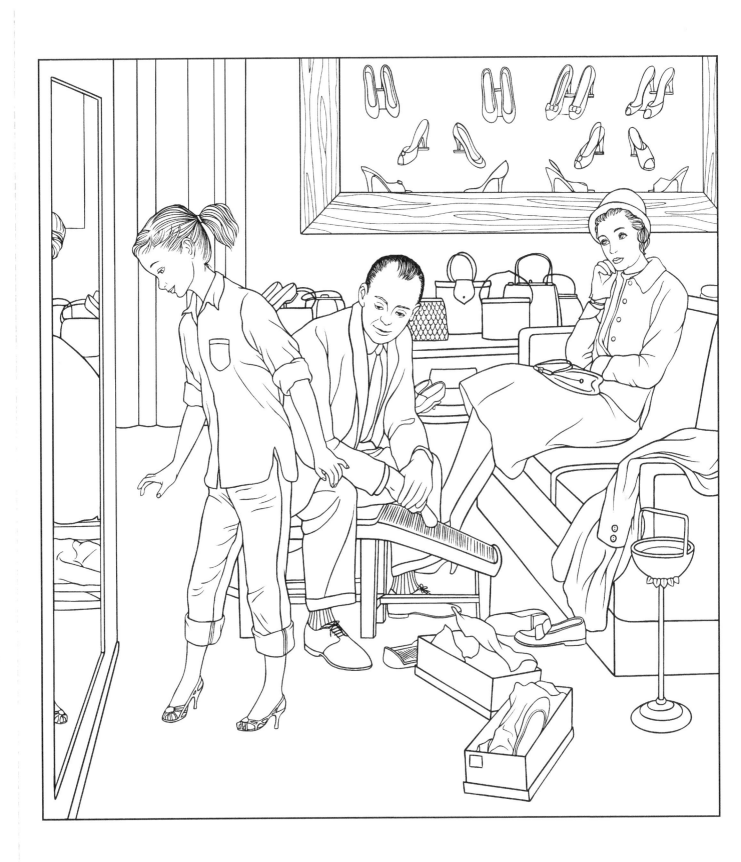

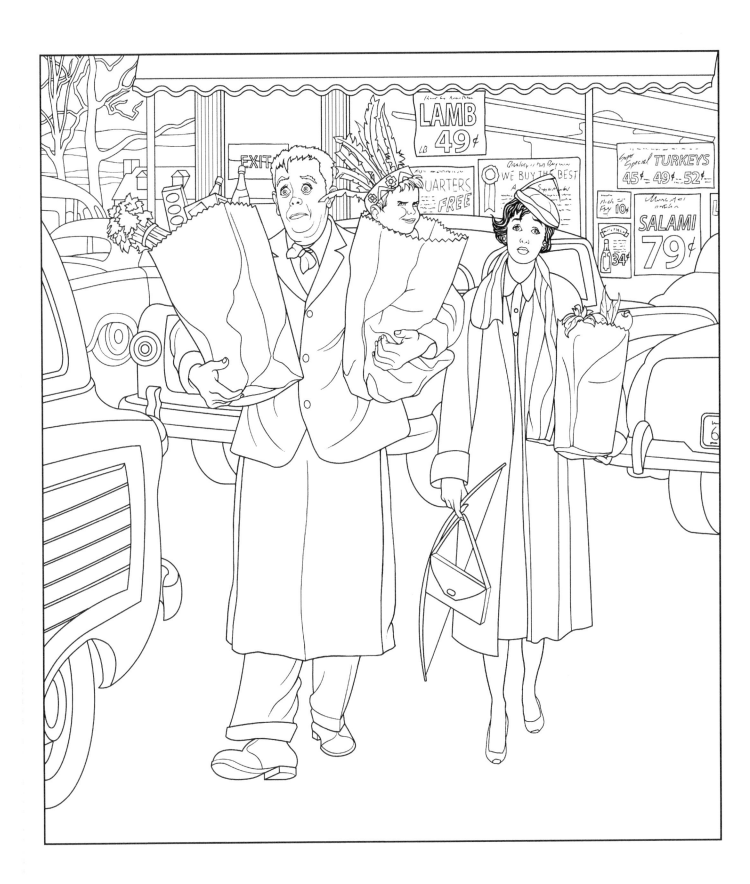

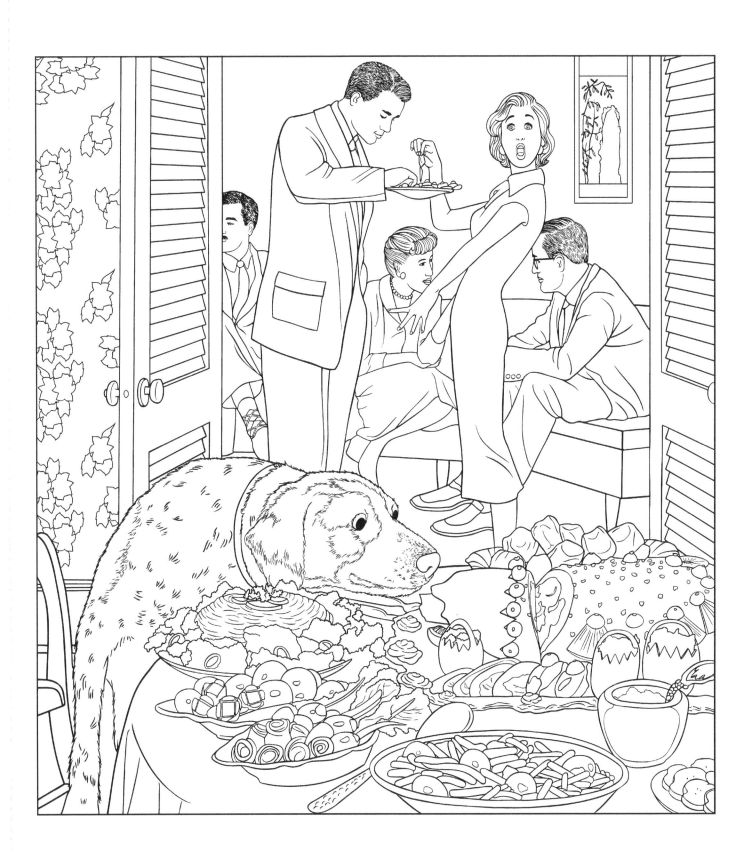

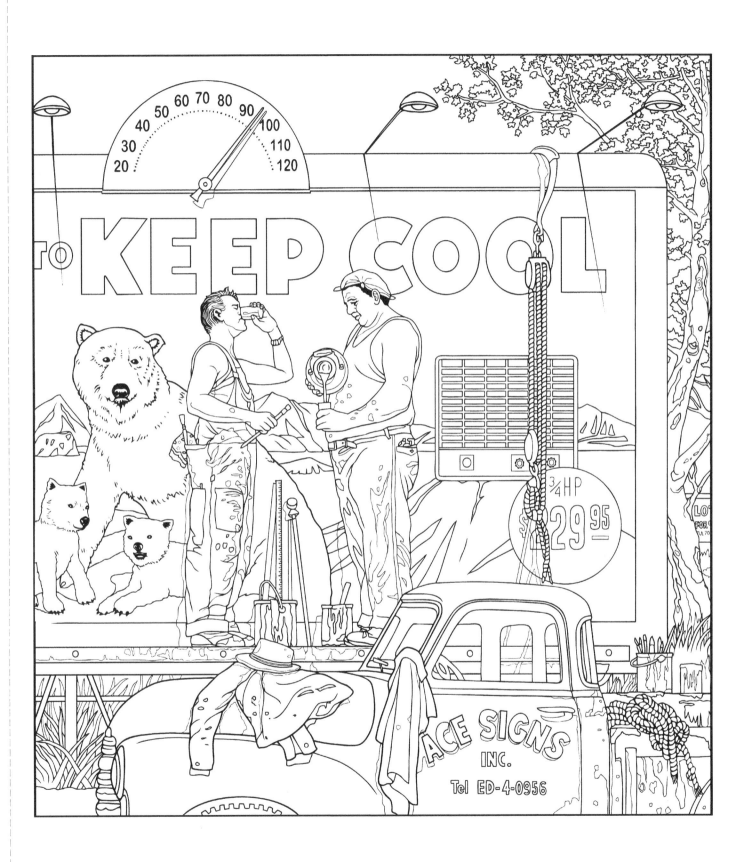

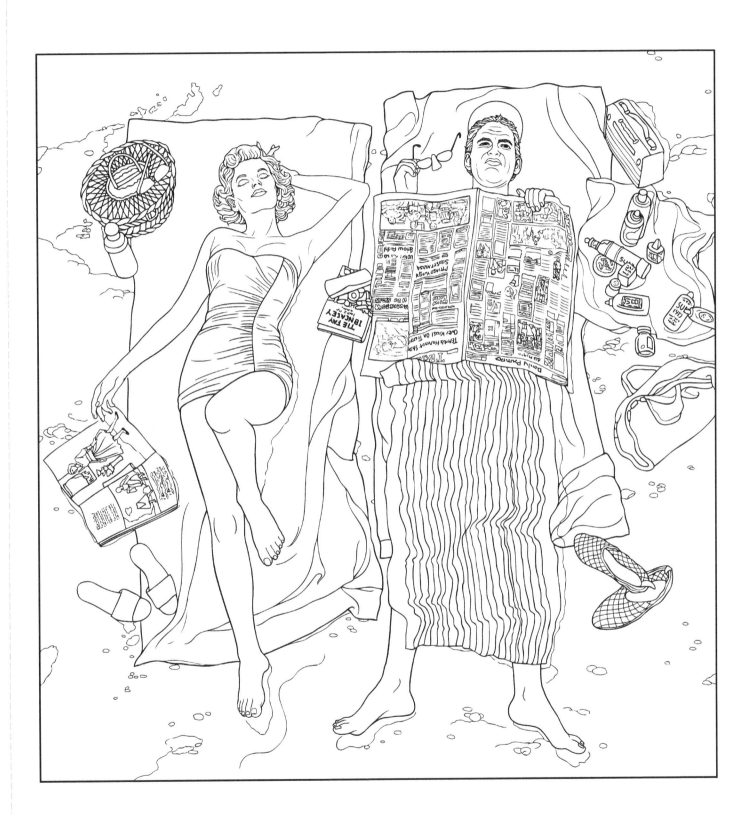

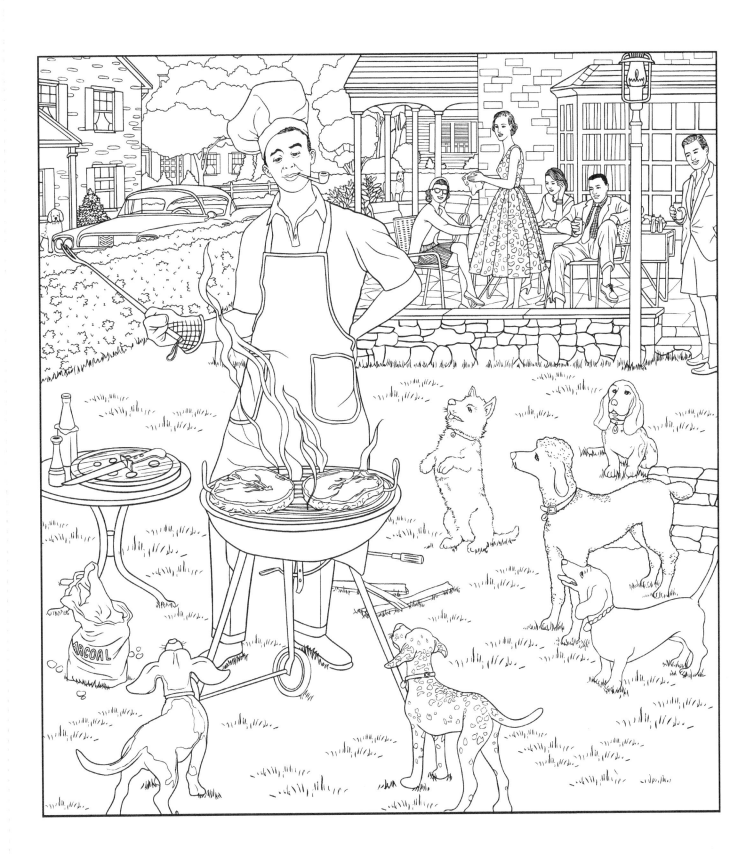

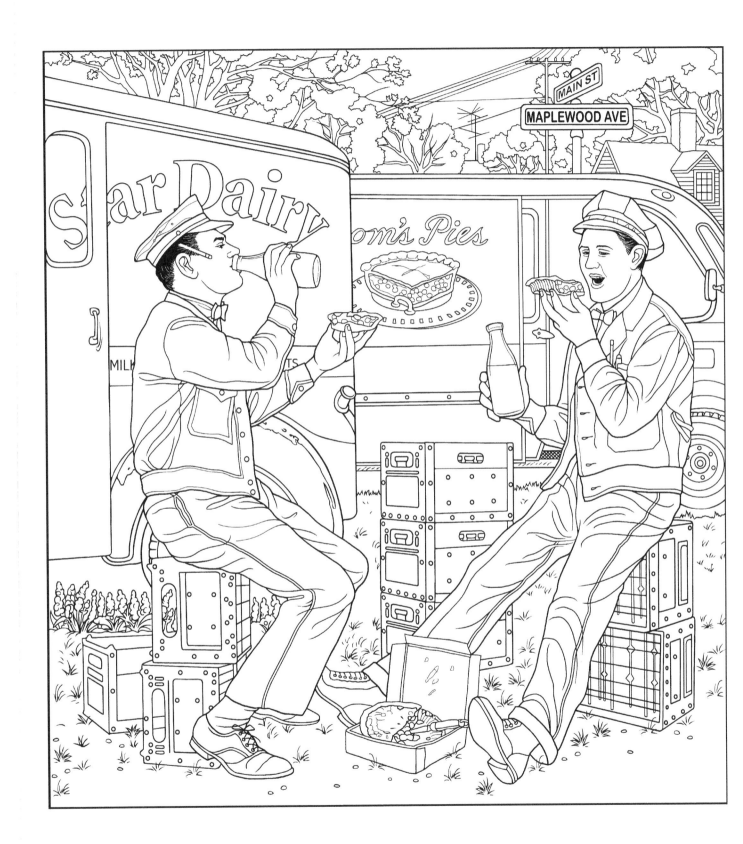

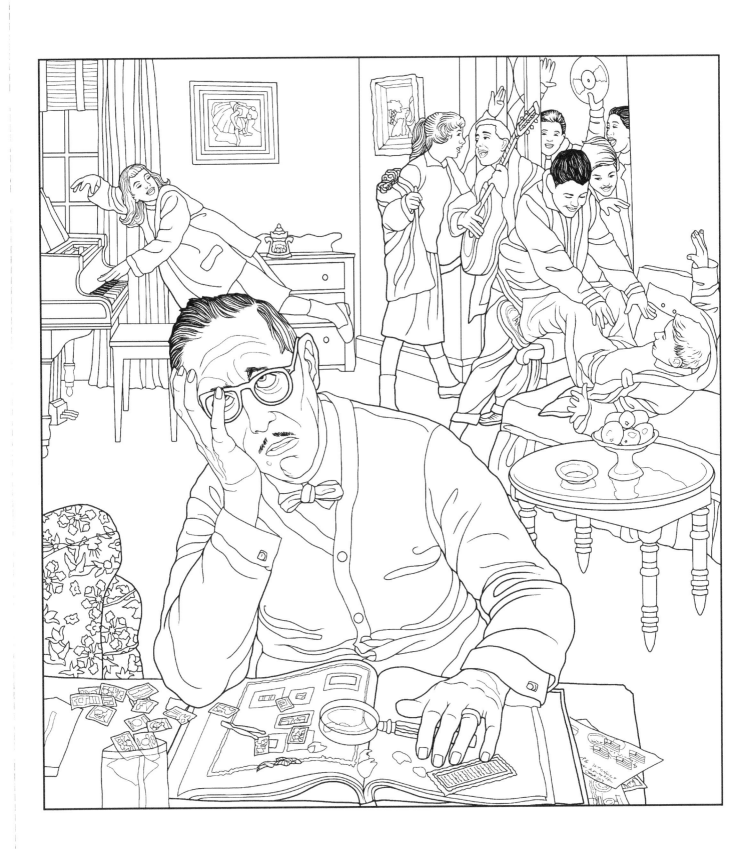

PLATE 29
No Quiet for Daddyo
Richard Sargent
Saturday Evening Post Cover, May 14, 1960

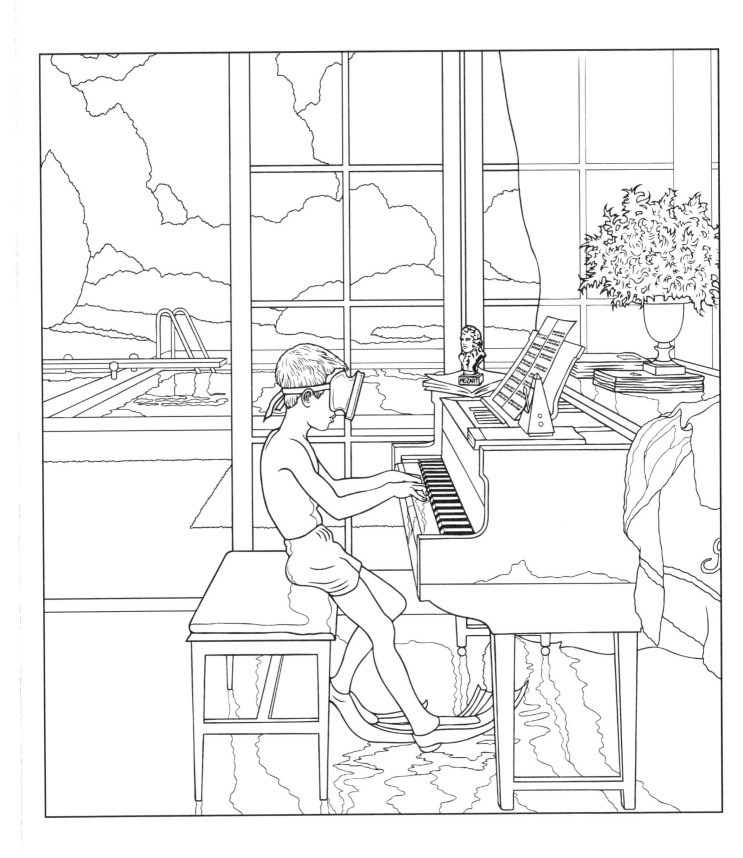

PLATE 30
Poolside Piano Practice
George Hughes
Saturday Evening Post Cover, June 11, 1960

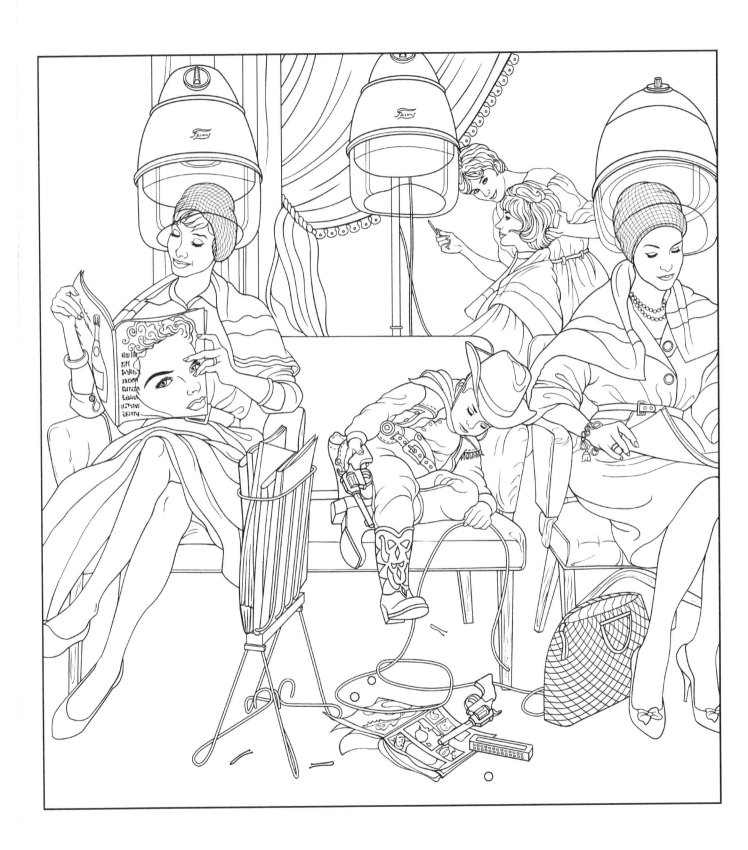